The Best

DINOSAURS

A-Z Alphabet Coloring Book
For Kids & Grown-ups!

ISBN: 978-1-944575-65-6

Copyright © 2018 by

Adult Coloring Book Publishers

Printed in the U.S.A

A is For

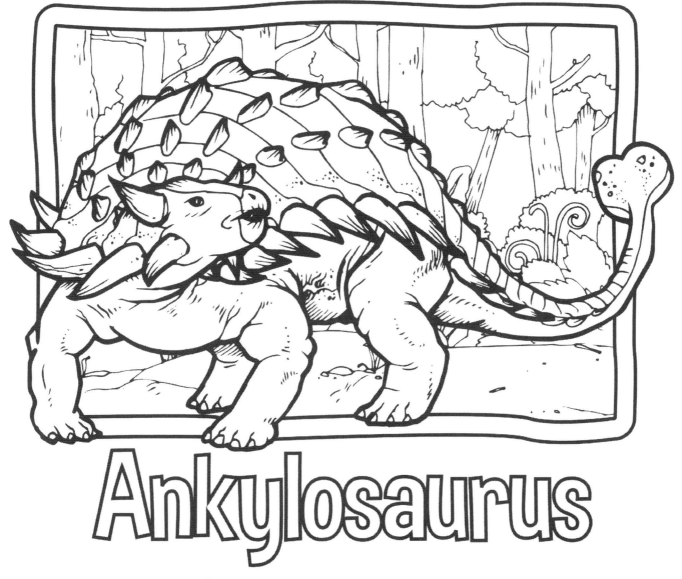

Ankylosaurus

Pronounced (ang-KILE-uh-SAWR-us) AKA- Fused Lizard
Its tough skin was covered with bony plates, and it could swing
its formidably clubbed tail to render a predator lame.

B is For

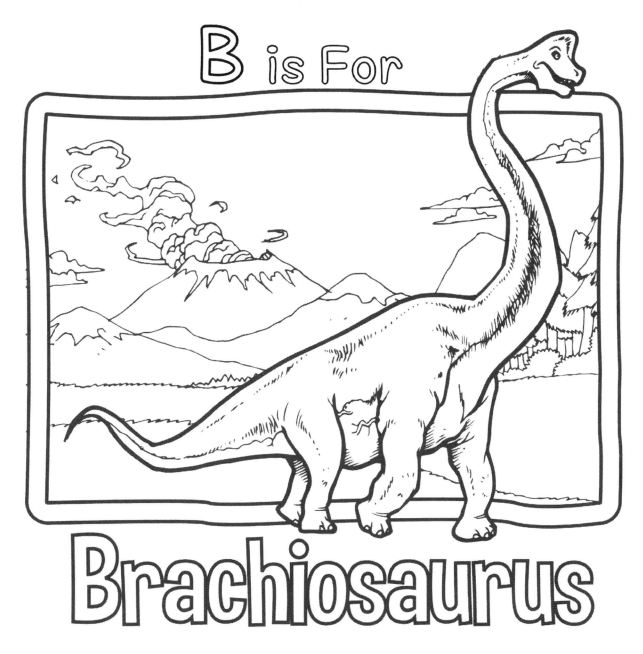

Brachiosaurus

Pronounced (BRACK-ee-uh-SAWR-us) AKA- Arm Lizard
Brachiosaurus is one of the largest known land animals.
Its front legs were longer than its rear legs and it stood
24 feet (7.3 meters) at the shoulder.

C is For

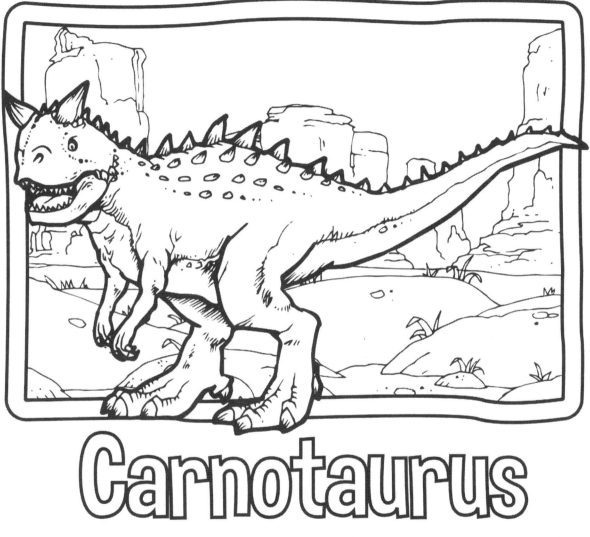

Carnotaurus

Pronounced (kahrn-uh-TAWR-us) AKA: Meat-Eating Bull
A strange-looking dinosaur with a short snout,
two bull-like horns, a weak jaw and small eyes.

D is For

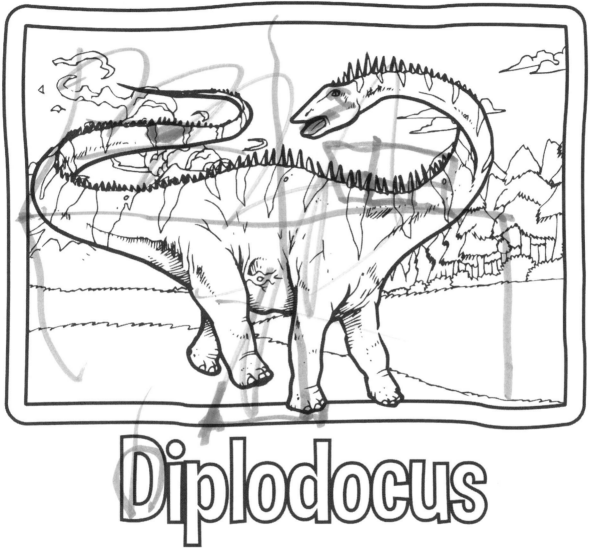

Diplodocus

Pronounced (dih-PLOD-uh-kus) AKA Double Beam
This Dinosaur was Discovered in the western United States.
It also had one of the smallest brains in Dinosauria.

E is For

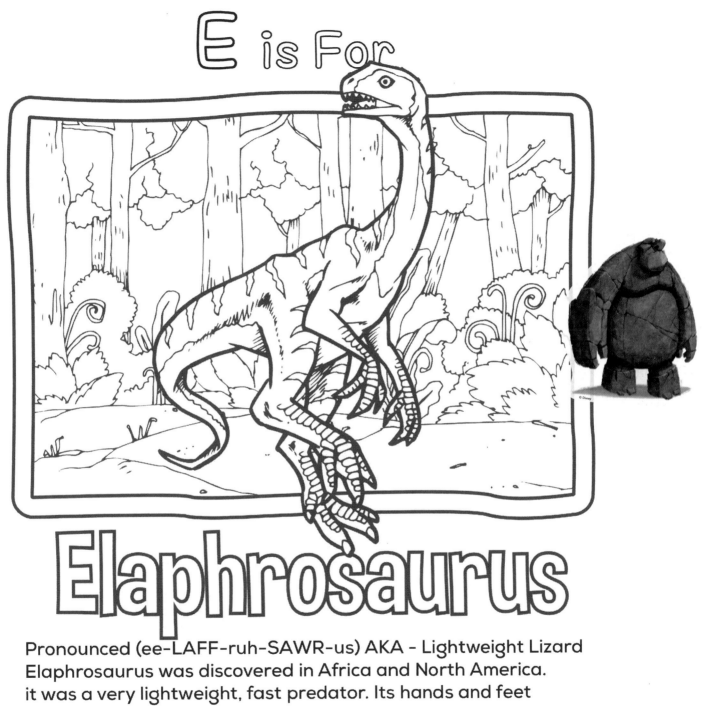

Elaphrosaurus

Pronounced (ee-LAFF-ruh-SAWR-us) AKA - Lightweight Lizard
Elaphrosaurus was discovered in Africa and North America.
it was a very lightweight, fast predator. Its hands and feet
each had three digits.

F is For

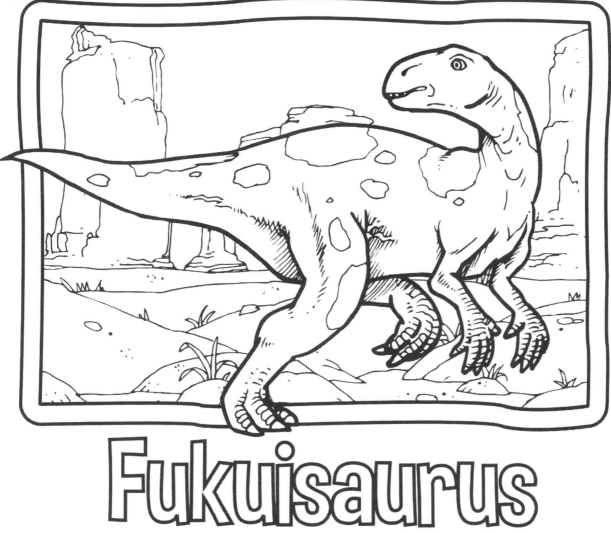

Fukuisaurus

Pronounced (foo-koo-i-SAWR-us) meaning "Fukui lizard"
is a genus of herbivorous dinosaur from the Early Cretaceous.
It was an ornithopod which lived in what is now Japan.

G is For

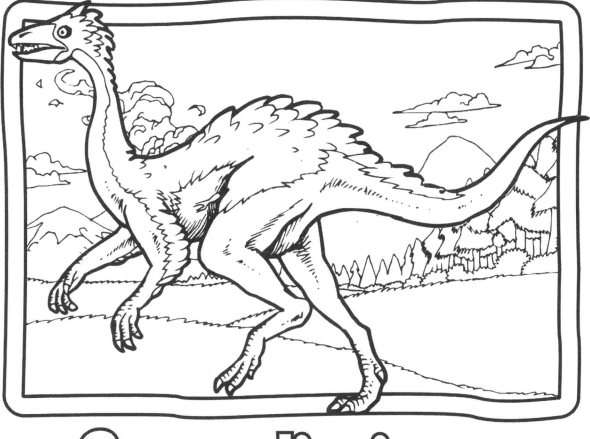

Garudimimus

Pronounced (gah-RUE-dih-my-mus) AKA- Garuda
This was found in southern Mongolia. Like other ornithomimids, it resembled the modern day ostrich. Unlike them, it had more toes (Four) and backward-pointing horns above its eyes.

H is For

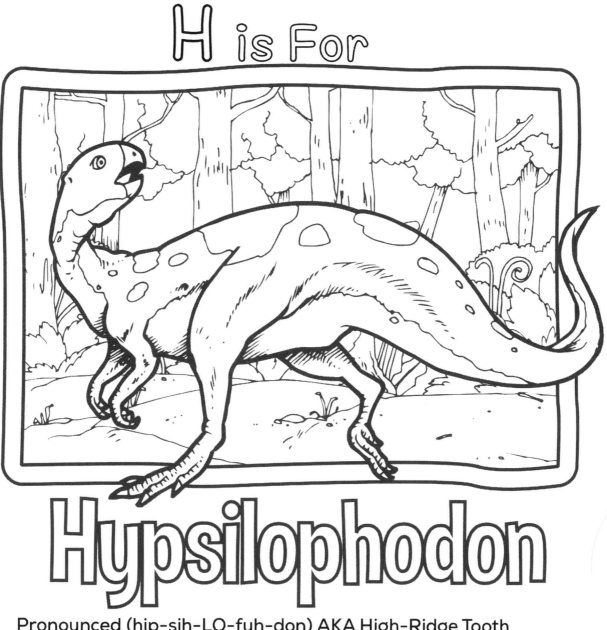

Hypsilophodon

Pronounced (hip-sih-LO-fuh-don) AKA High-Ridge Tooth
Its snout ended in a beak, but it had teeth at the rear of its mouth.
Hypsilophodon was once thought to have lived on trees,
though this has since been disproven.

I is For

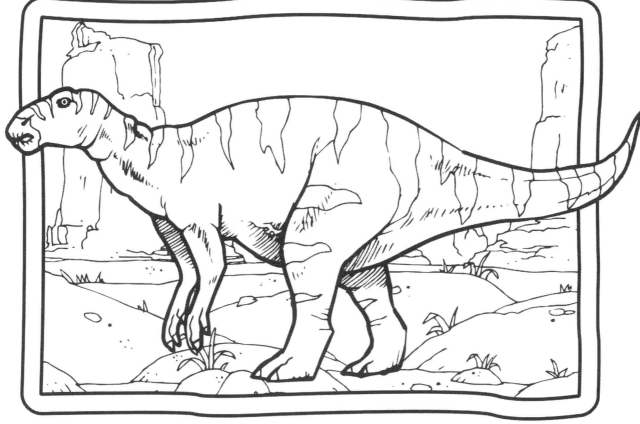

Iguanodon

Pronounced (ig-WAN-oh-don) AKA Iguana-tooth
Iguanodon received its name from the fact that it had teeth
resembling those of modern Iguana lizards, although much larger.

J is For

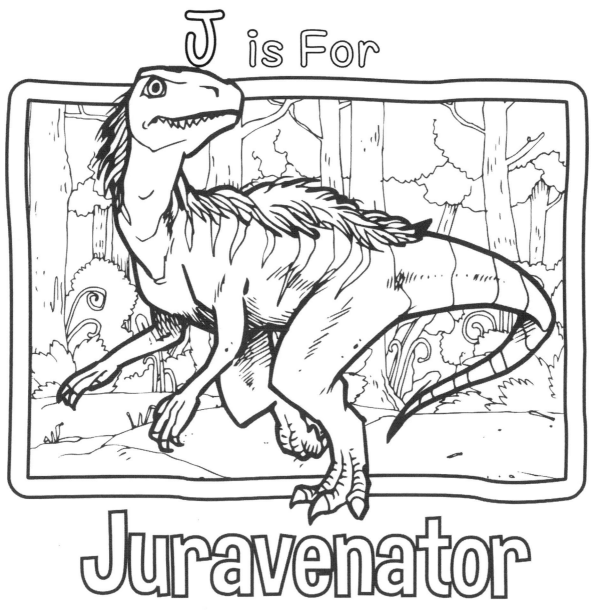

Juravenator

Pronounced (Joor-ah-ven-eat-or) This is a dinosaur with a height of two feet and weighs 300 grams. The term comes from the Greek and meaning of the term has a meaning hunter Jura Mountains.

K is For

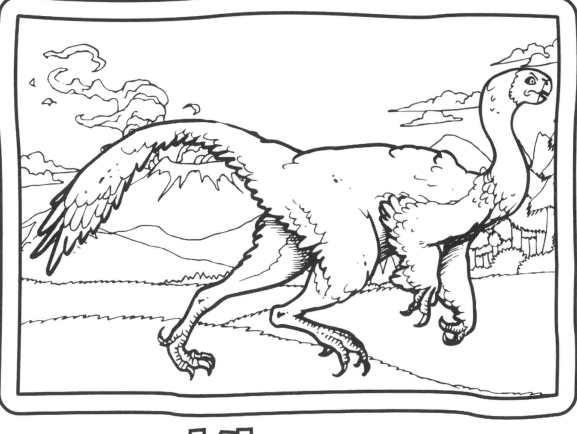

Khaan

pronounced (KAHN) Khaan is a type of dinosaur that has two legs and had feather-like structures. It is 4 feet long and weighs 30 pounds

L is For

Liaoxiornis

Pronounced (lyow-shee-or-nis)
About the size of a hummingbird, Liaoxiornis was the smallest
bird from the Cretaceous. Its feet could grasp a branch, so it could
perch—most of the other early birds could not do this.

M is For

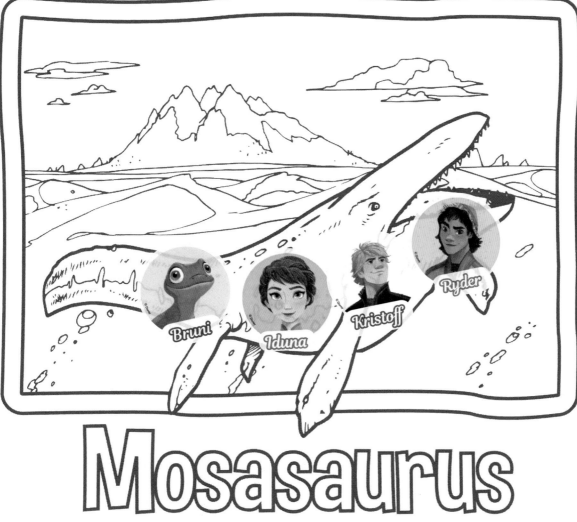

Mosasaurus

pronunced: (moh-suh-saw-rus)
which means "Lizard of the Meuse River".
This is a Carnivore Dinosaur. These apex predators of
the prehistoric deep can feast on all manner of ocean life.

N is For

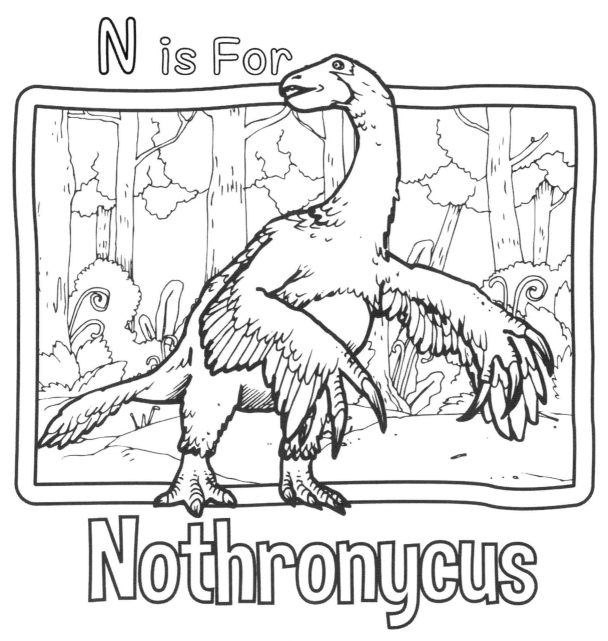

Nothronycus

pronounced (noh-throh-NI-kus) was a herbivorous theropod with a beak, a bird-like hip and four-toed feet, with all four toes facing forward.

O is For

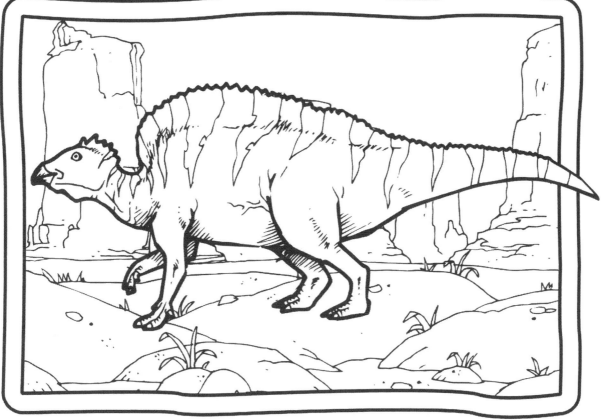

Ouranosaurus

Pronunced (ooh-RAN-uh-SAWR-us) AKA Valiant Lizard
Ouranosaurus was found in the Sahara Desert of Niger, Africa.

P is For

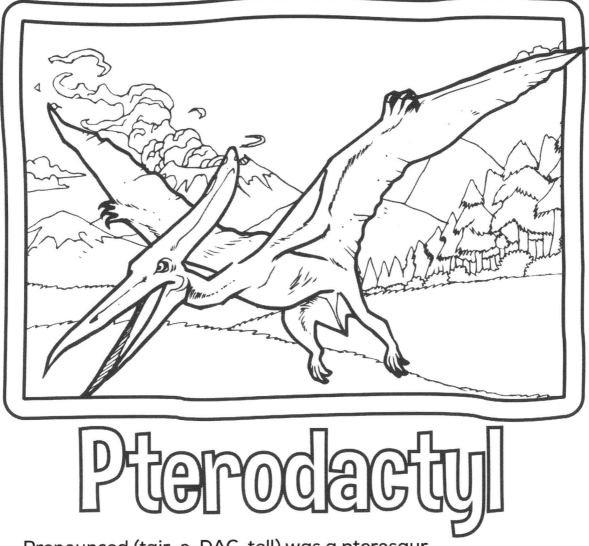

Pterodactyl

Pronounced (tair-o-DAC-tell) was a pterosaur,
a type of flying reptile. It was known to be a big flying dinosaur.

Q is For

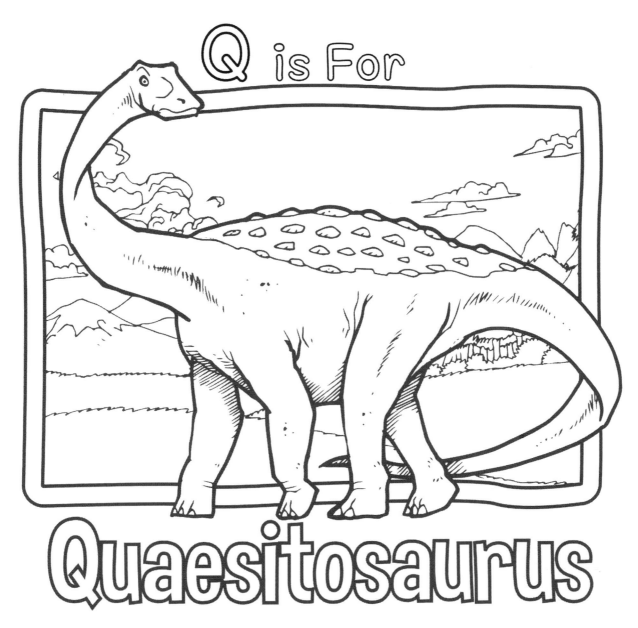

Quaesitosaurus

Pronounced (kway-ZEE-tuh-SAWR-us) AKA - Abnormal Lizard.
The animal is known only from a partial skull, which displays
unusual features, such as structures indicating sensitive hearing.

R is For

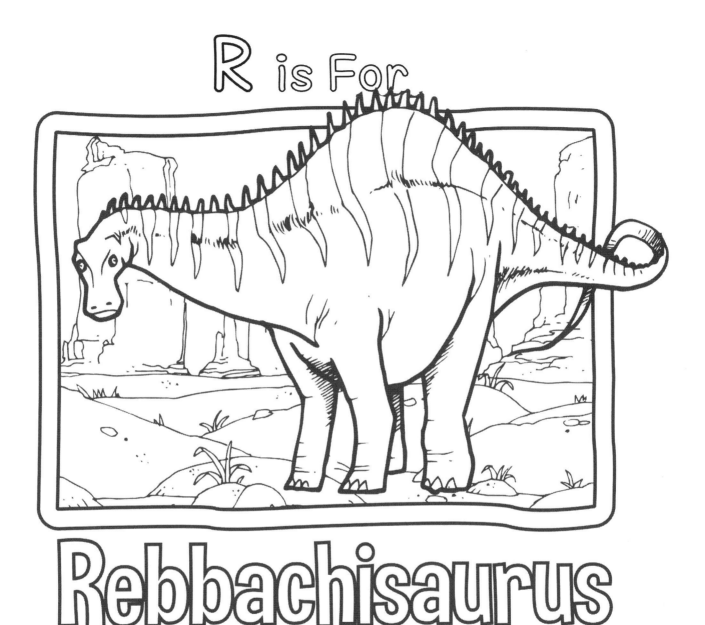

Rebbachisaurus

Pronounced (reeb-BAK-eh-SAWR-us) AKA- Rebbachi Lizard
Rebbachisaurus has been found in Morocco, Niger and Tunisia.
It resembles Dicraeosaurus but is larger.

S is For

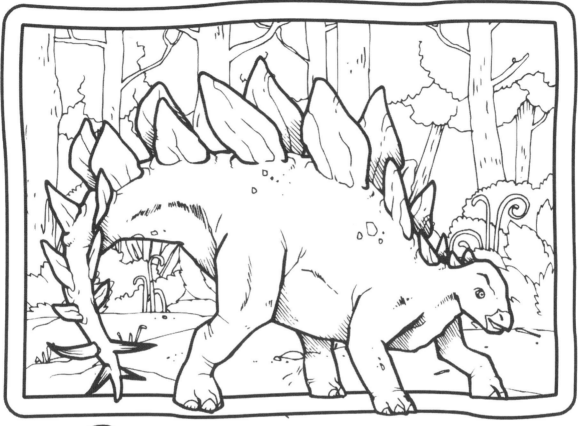

Stegosaurus

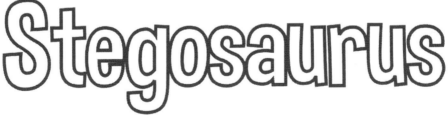

STEGOSAURUS Pronounced (STEG-uh-SAWR-us)
AKA - Roof Lizard. Stegosaurus is the only plated
dinosaur ever found in western North America.

T is For

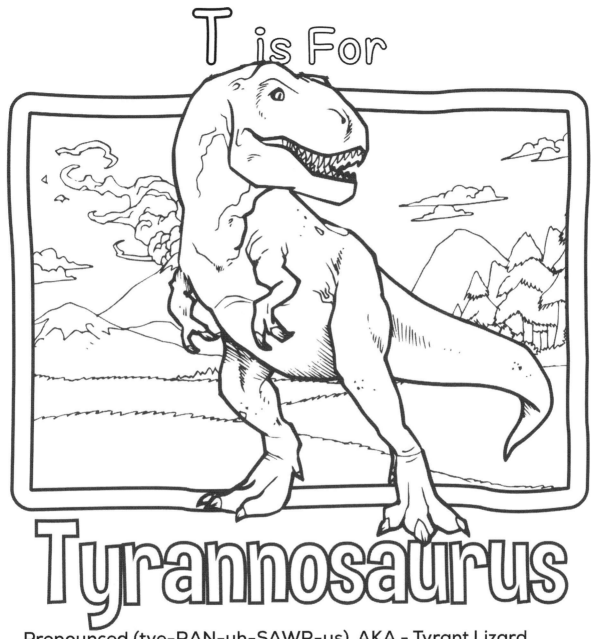

Tyrannosaurus

Pronounced (tye-RAN-uh-SAWR-us) AKA - Tyrant Lizard
One of the largest-ever flesh-eating land animals, Tyrannosaurus
is also the most famous, featured in most Dinosaur movies because
of its Spec.

U is For

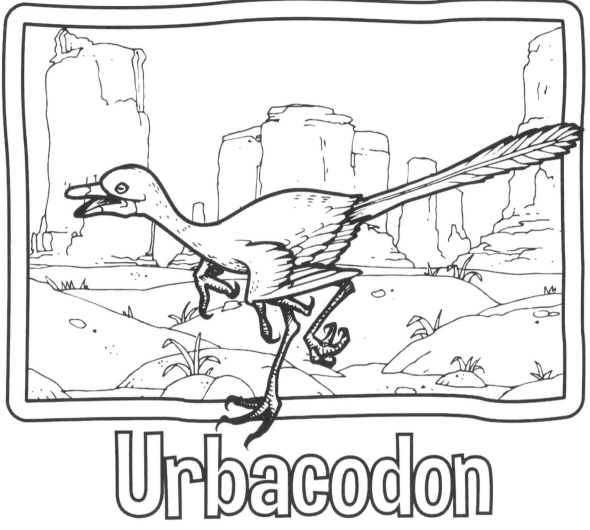

Urbacodon

Pronounced ("URBAC tooth") is a genus of troodontid dinosaur, a type of small carnivore.

V is For

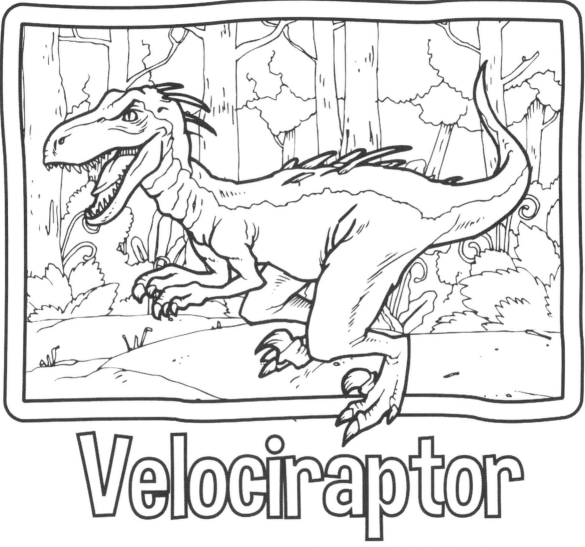

Velociraptor

Pronounced (veh-loss-ih-RAP-tor) AKA - Quick Plunderer
Found in Mongolia, China and Russia, Velociraptor was a ferocious
predator with the second toe of each foot bearing a formidably
large, retractable claw.

W is For

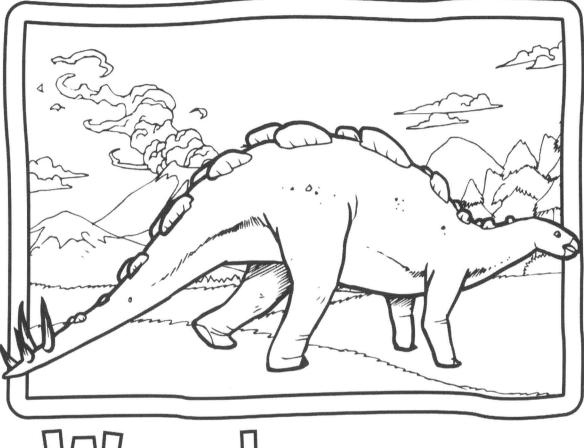

Wuerhosaurus

Pronounced (WER-oh-SAWR-us) AKA - Wuerho Lizard
This Dinosaurs Like other stegosaurs, it probably had two
rows of long, low bony plates down its neck, back, and upper tail.
Its tail was probably studded with four spikes.

X is For

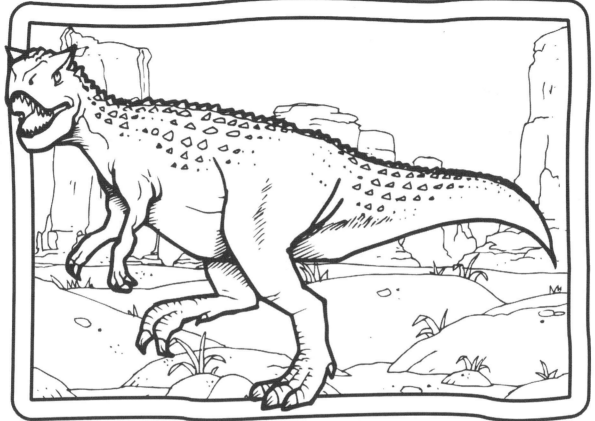

Xenotarsosaurus

Pronounced (zee-noh-TAR-suh-SAWR-us) known as Strange-Ankle Lizard
Xenotarsosaurus is known from fragmentary remains discovered in Argentina.
It had fused ankle bones -- an unusual feature in large predatory dinosaurs.

Y is For

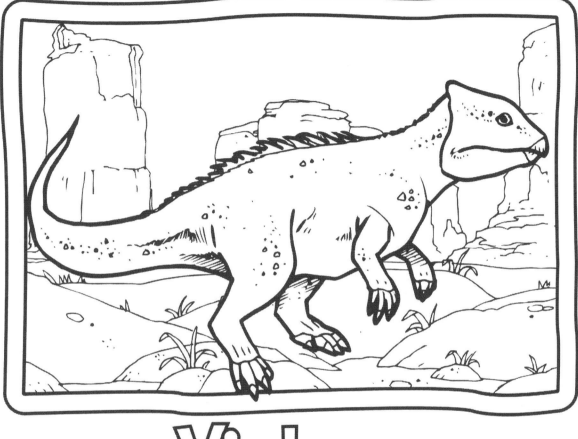

Yinlong

Pronounced (YIN-long) means "hidden dragon" is a genus of basal ceratopsian dinosaur from the Late Jurassic Period of central Asia. It was a small, primarily bipedal herbivore

Z is For

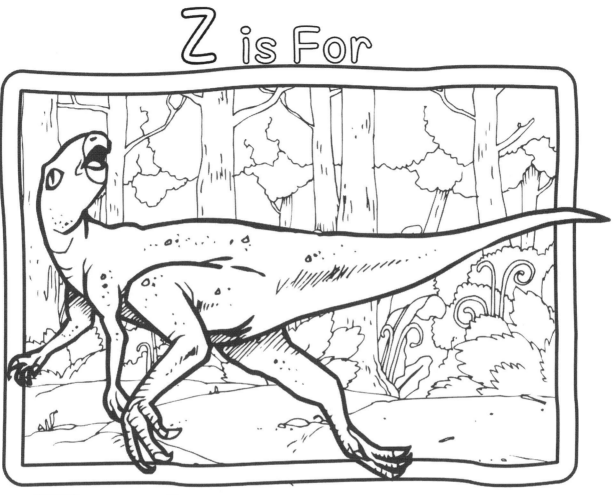

Zephyrosaurus

Pronounced (ZEF-fer-uh-SAWR-us) AkA - West Wind Lizard
Discovered in Montana, Zephyrosaurus had ridged teeth for
chewing plant food and was closely related to Hypsilophodon.

Glossary of Dinosaurs

ANKYLOSAURUS Pronounced **(ang-KILE-uh-SAWR-us)**
AKA- Fused Lizard

Height: 11 feet (3.4 meters)

Length: 35 feet (10.6 meters)

Weight: 10,000 lbs (4,536 kg)

Its tough skin was covered with bony plates, and it could swing its formidably clubbed

tail to render a predator lame.

BRACHIOSAURUS Pronounced **(BRACK-ee-uh-SAWR-us)**
AKA- Arm Lizard

Height: 50 feet (15.2 meters)

Length: 100 feet (30.5 meters)

Weight: 120,000 lbs (54,432 kg)

Brachiosaurus is one of the largest known land animals.

Its front legs were longer than its rear legs and it stood 24 feet (7.3 meters) at the shoulder.

It had small narrow feet for its size and the first digit of the front foot had a claw as did the first three digits of the hind foot.

The function of the claws is unknown though they may have been used for raking plants or in self defense.

CARNOTAURUS Pronounced **(kahrn-uh-TAWR-us)**
AKA: Meat-Eating Bull

Height: 13 feet (4 meters)

Length: 24.6 feet (7.5 meters)

Weight: 1,984 lbs (900 kg)

A strange-looking dinosaur with a short snout, two bull-like horns, a weak jaw and small eyes.

DIPLODOCUS Pronounced **(dih-PLOD-uh-kus)** AKA
Double Beam

Height: 30 feet (9.1 meters)
Length: 89 feet (27.1 meters)
Weight: 55,000 pounds (22,680 kg)

This Dinosaur was Discovered in the western United States.
Diplodocus had an elongated snout, with nostrils on top of the head and peglike teeth only at the front of its mouth.
Its limbs were slender and its hind legs were longer than the front legs giving it access to both low and high growing plants.
It also had one of the smallest brains in Dinosauria.

ELAPHROSAURUS Pronounced **(ee-LAFF-ruh-SAWR-us)**
AKA Lightweight Lizard

Height: 6.5 feet (2 meters)

Length: 11 feet (3.4 meters)

Elaphrosaurus was discovered in Africa and North America.

One of the earliest members of the ornithomimid family, it was a very lightweight, fast predator. Its hands and feet each had three digits.

Fukuisaurus Pronounced **(foo-koo-i-SAWR-us)** meaning "Fukui lizard" is a genus of herbivorous dinosaur from the Early Cretaceous. It was an ornithopod which lived in what is now Japan.

GARUDIMIMUS Pronounced **(gah-RUE-dih-my-mus)**

AKA- Garuda (a mythological bird) Mimic

Height: 7 feet (2.1 meters)

Length: 11.8 feet (3.6 meters)

Garudimimus was found in southern Mongolia. Like other ornithomimids, it resembled the modern day ostrich.

Unlike them, it had more toes (4) and backward-pointing horns above its eyes.

HYPSILOPHODON Pronounced **(hip-sih-LO-fuh-don)**
AKA High-Ridge Tooth

Height: 4 feet (1.2 meters)

Length: 7.5 feet (2.3 meters)

Weight: 140 pounds (64 kg)

Hypsilophodon was the fastest of the ornithischians that lived in central United States, England, Spain and Portugal.

Its snout ended in a beak, but it had teeth at the rear of its mouth.

Hypsilophodon was once thought to have lived in trees, though this has since been disproven.

defense.

IGUANODON Pronounced **(ig-WAN-oh-don)** AKA Iguana-tooth

Height: 16 feet (4.9 meters)

Length: 26 feet (7.9 meters)

Weight: 10,000 pounds (4,536 kg)

Iguanodon received its name from the fact that it had teeth resembling those of modern Iguana lizards, although much larger.

Juravenator Pronounced **(Joor-ah-ven-eat-or)**
This is a dinosaur with a height of two feet and weigh 300 gramsThe term comes from the Greek and meaning of the term has a meaning hunter Jura Mountains.

Khaan : pronounced **(KAHN)** Khaan is a type of dinosaur that has two legs and had feather-like structures. It is 4 feet long and weighs 30 pounds

Liaoxiornis: pronounced **(lyow-shee-or-nis)** About the size of a hummingbird, Liaoxiornis was the smallest bird from the Cretaceous. Its feet could grasp a branch, so it could perch—most of the other early birds could not do this.

Mosasaurus. pronunced: **(moh-suh-saw-rus)** which means "Lizard of the Meuse River. Size. 9.8. Ft. 55. Ft. Weight. 28. Tons. This is a Carnivore Dinosaur. These apex predators of the prehistoric deep can feast on all manner of ocean life.

Nothronychus pronounced **(noh-throh-NI-kus)** was a herbivorous theropod with a beak, a bird-like hip and four-toed feet, with all four toes facing forward.

OURANOSAURUS Pronunced **(ooh-RAN-uh-SAWR-us)**

AKA Valiant Lizard

Height: 10 feet (3.1 meters)

Length: 23 feet (7.0 meters)

Weight: 8,000 pounds (3,629 kg)

Ouranosaurus was found in the Sahara Desert of Niger, Africa.

Pterodactyl: Pronounced **(tair-o-DAC-tell)** was a pterosaur, a type of flying reptile. It was known to be a big flying dinosaur.

PARASAUROLOPHUS Pronounced **(par-ah-SAWR-OL-uh-fus)** AKA Similar Crested Lizard

Height: 16 feet (4.9 meters)

Length: 33 feet (10.1 meters)

Weight: 6,000 - 8,000 pounds

(2,720 - 3,630 kg)

Parasaurolophus has been found in Utah, New Mexico, and Alberta, Canada.

The remarkable crest of this duck-billed dinosaur was a hollow tube 5 feet (1.5 meters) long that extended back over the animal's shoulders.

The purpose of this crest may have been to improve the dinosaur's sense of smell, or it may have served as a resonance chamber to allow for trumpetlike sounds.

QUAESITOSAURUS Pronounced **(kway-ZEE-tuh-SAWR-us)**

AKA - Abnormal Lizard

Height: 25 feet (7.6 meters)

Length: 65 feet (19.8 meters)

The animal is known only from a partial skull, which displays unusual features, such as structures indicating sensitive hearing.

REBBACHISAURUS Pronounced **(reeb-BAK-eh-SAWR-us)**
AKA Rebbachi Lizard

Height: 30 feet (9.1 meters)

Length: 65.6 feet (20 meters)

Rebbachisaurus has been found in Morocco, Niger and Tunisia. It resembles Dicraeosaurus but is larger.

STEGOSAURUS Pronounced **(STEG-uh-SAWR-us)** AKA - Roof Lizard

Height: 14 feet (4.3 meters)

Length: 28 feet (8.5 meters)

Weight: 6,000 pounds (2,722 kg)

Stegosaurus is the only plated dinosaur ever found in western North America.

TYRANNOSAURUS Pronounced **(tye-RAN-uh-SAWR-us)**
AKA - Tyrant Lizard

Also Known As: Tarbosaurus

Height: 23 feet (7.0 meters)

Length: 50 feet (15.2 meters)

Weight: 16,000 pounds (7,258 kg)

One of the largest-ever flesh-eating land animals, Tyrannosaurus is also the most famous, featured in most Dinosaur movies because of its Spec.

Urbacodon pronounced **("URBAC tooth")** is a genus of troodontid dinosaur, a type of small carnivore.

VELOCIRAPTOR Pronounced **(veh-loss-ih-RAP-tor)**

AKA - Quick Plunderer

Height: 2.5 feet (0.8 meters)

Length: 5.9 feet (1.8 meters)

Weight: 200 pounds (91 kg)

Found in Mongolia, China and Russia, Velociraptor was a ferocious predator with the second toe of each foot bearing a formidably large, retractable claw.

WUERHOSAURUS Pronounced **(WER-oh-SAWR-us)**

AKA - Wuerho Lizard

Height: 9 feet (2.2 meters)

Length: 23 feet (7 meters)

This Dinosaurs Like other stegosaurs, it probably had two rows of long, low bony plates down its neck, back, and upper tail.

Its tail was probably studded with four spikes.

XENOTARSOSAURUS Pronounced **(zee-noh-TAR-suh-SAWR-us)** known as Strange-Ankle Lizard

Xenotarsosaurus is known from fragmentary remains discovered in Argentina. It had fused ankle bones -- an unusual feature in large predatory dinosaurs.

Yinlong pronounced (YIN-long) means "hidden dragon" is a genus of basal ceratopsian dinosaur from the Late Jurassic Period of central Asia. It was a small, primarily bipedal herbivore

ZEPHYROSAURUS Pronounced **(ZEF-fer-uh-SAWR-us)**
AkA - West Wind Lizard

Height: 3 feet (0.9 meters)

Length: 6.6 feet (2 meters)

Discovered in Montana, Zephyrosaurus had ridged teeth for chewing plant food and was closely related to Hypsilophodon.

Thank You

If you enjoyed Coloring this Beautiful Dinosaurs A-Z Alphabet Books For Kids & Grownups, please take a little time to share your thoughts and post a positive review with 5 star rating on Amazon,

It would encourage me and make me serve you better.

It will Really be appreciated.

We'll never be perfect, but that won't stop us from trying. Your feedback makes us serve you better. Send ideas, criticism, Compliment or anything else you think we should hear to info@colormom.com. We'll Reply you As soon as we receive your Mail. :)

Visit Our Author Page For More Amazing Books For Kids and Grown-Ups!

Staci Giron

cat

Printed in Poland
by Amazon Fulfillment
Poland Sp. z o.o., Wrocław